LUDLOW
HISTORY TOUR

First published 2019

Amberley Publishing
The Hill, Stroud,
Gloucestershire, GL5 4EP
www.amberley-books.com

Copyright © Dorothy Nicolle, 2019
Map contains Ordnance Survey data
© Crown copyright and database
right [2019]

The right of Dorothy Nicolle to be
identified as the Author of this work
has been asserted in accordance with
the Copyrights, Designs and Patents
Act 1988.

ISBN 978 1 4456 9324 8 (print)
ISBN 978 1 4456 9325 5 (ebook)

British Library Cataloguing in
Publication Data.
A catalogue record for this book is
available from the British Library.

Origination by Amberley Publishing.
Printed in Great Britain.

ABOUT THE AUTHOR

Dorothy Nicolle came to live in Shropshire some thirty years ago and fell in love with the county. She then decided that the best job in the world would be to share her discoveries with anyone else who might be interested and so, in 1993, she qualified as a Blue Badge tourist guide. In the years since she has lectured on various local history themes and has also written a number of books on both local and general history. For information about her tours, talks and books please visit her website at www.nicolle.me.uk.

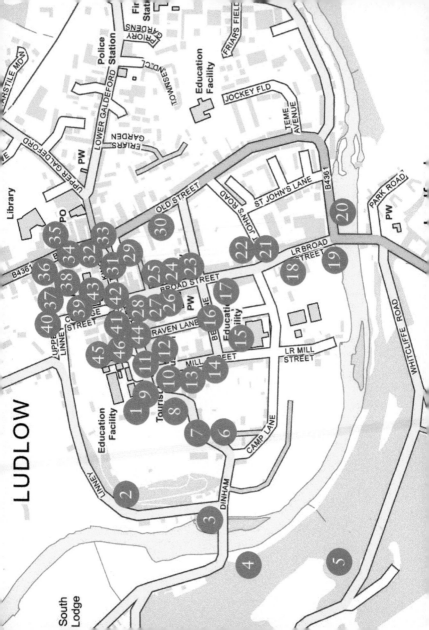

KEY

1. Ludlow Castle
2. Castle Walks
3. Dinham Bridge
4. The Breadwalk
5. Whitcliffe Common
6. St Thomas's Chapel
7. Dinham Hall
8. Castle Gardens
9. Castle Square
10. Castle Lodge
11. Castle Square –
 The Market Place
12. The Assembly Rooms
13. Mill Street – The Blue Boar
14. Mill Street – The Guildhall
15. Mill Street – Ludlow College
16. Bell Lane
17. Broad Street
18. Lower Broad Street
19. Ludford Bridge
20. The River Teme
21. The Broadgate
22. Broad Street – The Broadgate
23. Broad Street – The Old Bank
24. Broad Street – Lloyds Bank
25. Broad Street –
 Old Angel Hotel
26. The Buttercross
27. High Street
28. Broad Street –
 Bodenhams
29. Fish Street and Pepper Lane
30. Old Street –
 Lane's Asylum
31. The Narrows
32. The Bull Ring
33. The Tolsey
34. Corve Street
35. The Feathers Hotel
36. The Bull Hotel
37. St Lawrence's Church –
 The Churchyard
38. The Reader's House
39. A. E. Housman
40. College Street
41. Hosier's Almshouses
42. St Lawrence's Church –
 The Porch
43. St Lawrence's Church –
 The Interior
44. Church Street
45. Quality Square
46. The Market Square

INTRODUCTION

Ludlow sits on a wonderfully strategic site, something that becomes immediately apparent if you are lucky enough to approach from the north. Despite its excellent position it seems that our Anglo-Saxon and earlier ancestors ignored its potential and came here only to cross the River Teme at a convenient fording point – the name Old Street serves as a reminder of this early trackway.

It was the Normans who decided to develop the site and as early as the 1080s they started building a castle overlooking the river to the west and south and with an excellent view to the north. Soon local people gravitated to the area to trade and so a market developed by the castle's east gate. Around the market a town then grew, all carefully laid out in a grid pattern that is immediately obvious even now.

It was in the sixteenth century that Ludlow truly became important. England and Wales had only recently become united under the Tudor king, Henry VII. Wales needed to be administered, Westminster was at the other end of the country and it was Ludlow that was then chosen as the administrative centre for Wales and the borders. Henry's eldest son, Arthur, Prince of Wales, and his bride, Catherine of Aragon, came too and their court soon followed. For the next 200 years Ludlow was a centre for administration and law as well as for the society of the day.

The eighteenth century saw the development of decent roads for stagecoaches, and the nineteenth century saw the introduction of the

railways. Wales could now be centrally administered; Ludlow was no longer needed. Consequently the town fell into a gentle decline that has proved to be a godsend, so today Ludlow is a true gem not only for its fascinating stories but especially because of its superbly varied architecture reflecting the many facets of the town's history.

Walking around the town you'll notice that Ludlow has a wealth of blue information plaques on buildings. Do take the time to read them as you go.

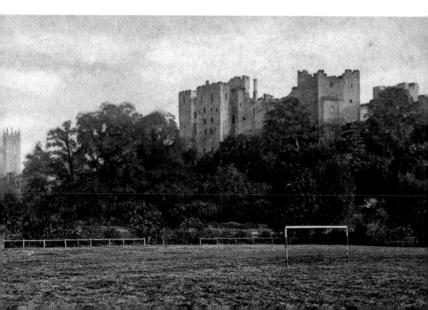

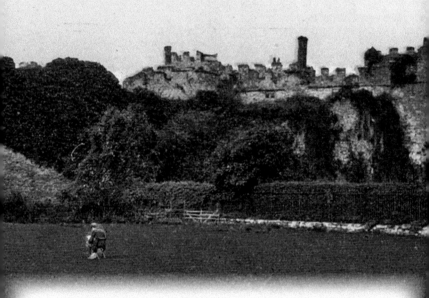

1. LUDLOW CASTLE

Ludlow's castle is unusual in that there was never an early wooden castle here; instead this castle was stone-built right from the start. The early keep, pictured here, was built using stone from the moat that surrounds it – that moat sits at the top of the hill and never held water. By the fourteenth century this castle had become palatial and was for many years a stronghold of the powerful Mortimer family.

2. CASTLE WALKS

This path around the castle was first laid out in the 1770s on the orders of the Earl and Countess of Powis, who were then leasing the castle. It was a 'New Walk' so that the people of Ludlow could enjoy the picturesque views over the river. Costings for the walks included £22 11s for trees – a phenomenal amount for the time. Sadly, these days the trees tend to obscure the best of the views!

LUDLOW

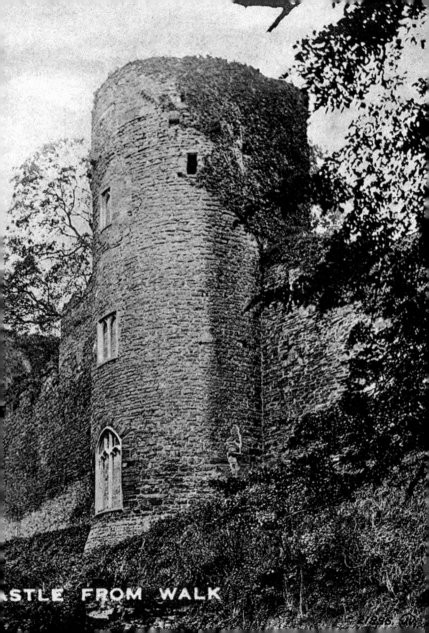

ASTLE FROM WALK

3. DINHAM BRIDGE

We don't know when the first bridge was built here but a 'new' bridge was built in 1540, costing 30s. The present bridge, however, dates from 1823. If you are lucky enough to be spending a few days in Ludlow, then do try to find the time to take a walk to visit locations 4 and 5 – the views alone will make it worth your while.

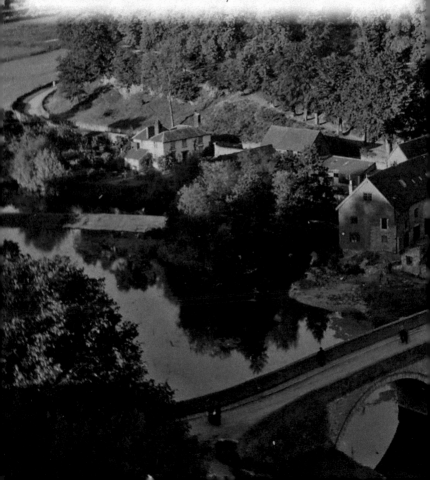

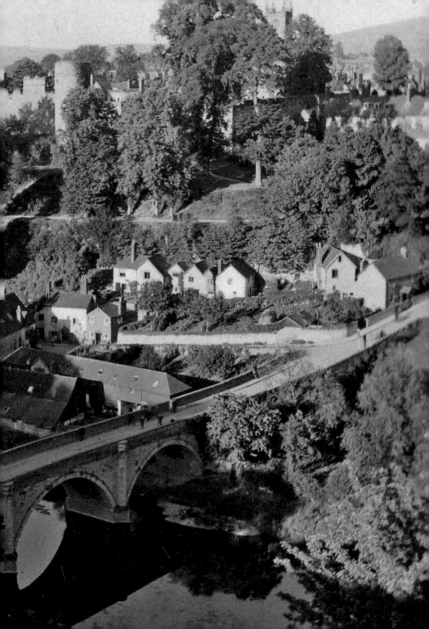

4. THE BREADWALK

What an odd name for a walk! The early 1800s saw considerable suffering in the region as a result of unemployment so the idea was conceived to give local people work by employing them to develop this footpath. The name comes about because they were paid in bread so that they didn't squander any earnings in the local pubs. I'm not sure if the publicans thought this was a good idea.

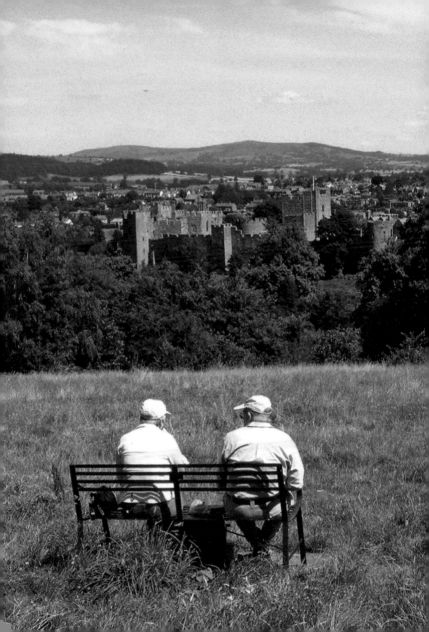

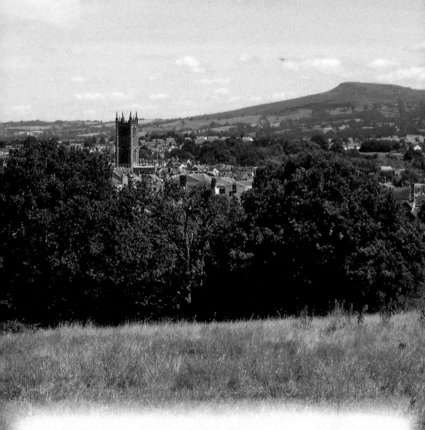

5. WHITCLIFFE COMMON

The best view of the town of Ludlow and beyond towards the Clee Hills is from Whitcliffe Common; indeed, many would say it's the best view in Shropshire. Once a much larger area where local commoners could graze their livestock, today the common covers an area of 52 acres and is rich in wild flowers – the grass is cut just once a year to allow flowering plants time to seed.

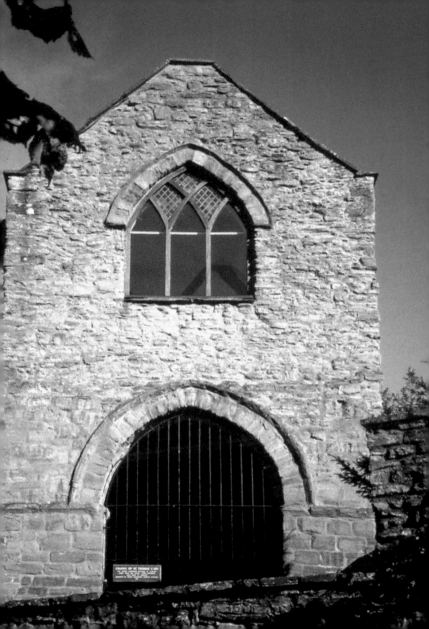

6. ST THOMAS'S CHAPEL

This little chapel dates from the end of the twelfth century and was dedicated to St Thomas à Becket. If you look behind it, however, you will see what appears to be a private house. This conversion was done in the eighteenth century.

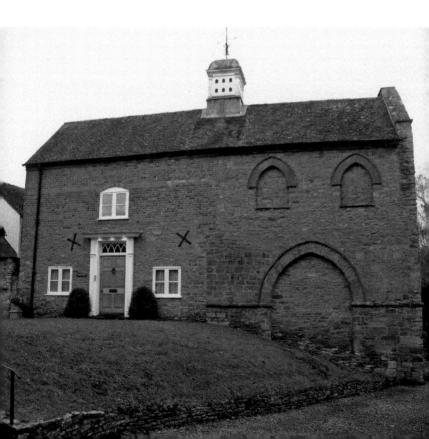

7. DINHAM HALL

Lucien Bonaparte, brother of Napoleon, was imprisoned here in 1811. Lucien fell out with his brother and decided to move to the United States but was captured by the British Navy on the way. His imprisonment cannot have been that harsh – he was accompanied by his wife and family along with twenty-three servants.

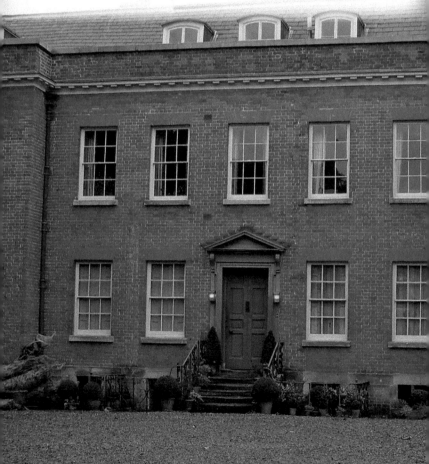

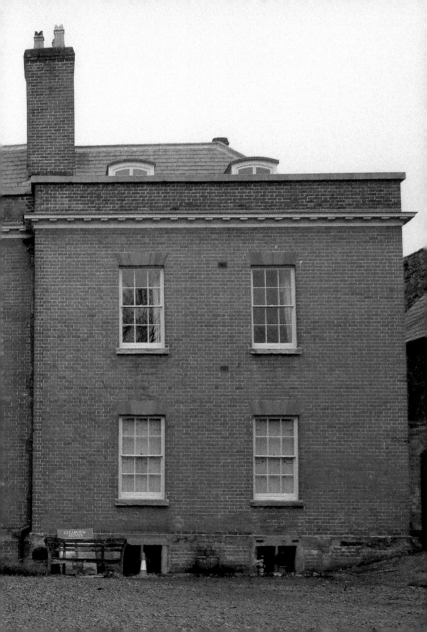

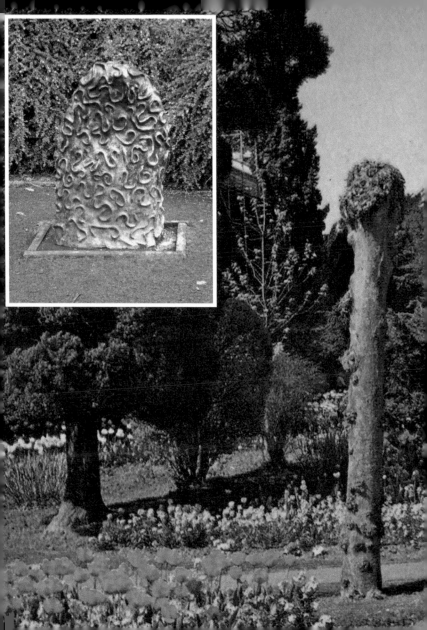

8. CASTLE GARDENS

Although the planting these days is much more economic to maintain than it was in the 1950s when this photograph was taken, this is still a very pleasant place to walk or rest awhile. The strange sculpture pictured in the inset photo is by local blind artist Seren Thomas. This is art that must be touched to be enjoyed.

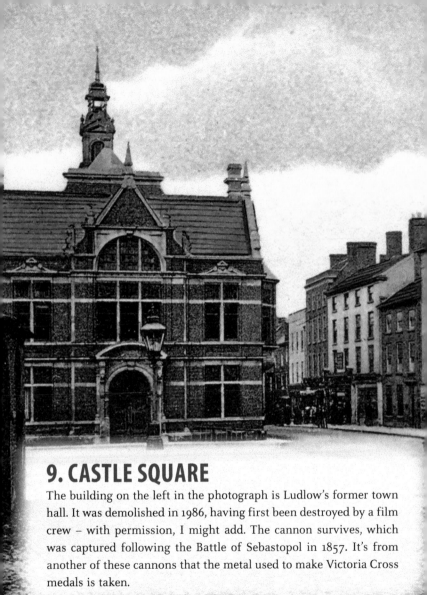

9. CASTLE SQUARE

The building on the left in the photograph is Ludlow's former town hall. It was demolished in 1986, having first been destroyed by a film crew – with permission, I might add. The cannon survives, which was captured following the Battle of Sebastopol in 1857. It's from another of these cannons that the metal used to make Victoria Cross medals is taken.

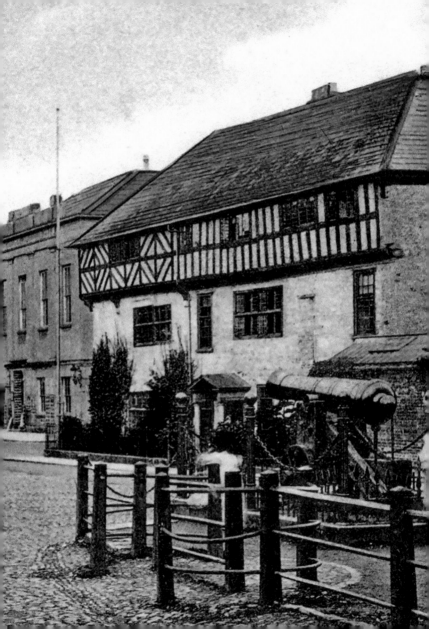

10. CASTLE LODGE

Now privately owned, Castle Lodge was built in the 1570s, with the timber top floor added around 1600. At one time it was used to imprison those brought to attend court cases in town. It was then described as 'such a place of punishment as the common people termed it a hell'. Occasionally open to the public, it has wonderful plaster ceilings, panelled walls and even, supposedly, a ghost.

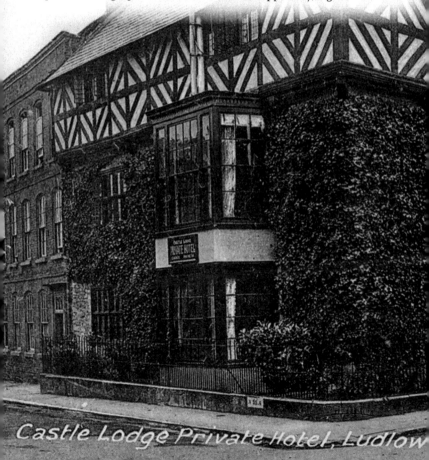

Castle Lodge Private Hotel, Ludlow

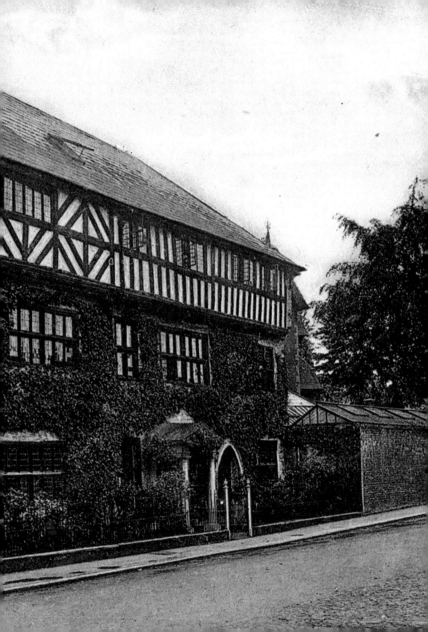

11. CASTLE SQUARE – THE MARKET PLACE

From here we begin to get an impression of the size of the original medieval market. It must be borne in mind, however, that the buildings at the far end all sit within what was then an open market area that extended for some distance behind them. Regular market days are still held here. Indeed, *Country Life* magazine recently described Ludlow as being 'England's finest market town'.

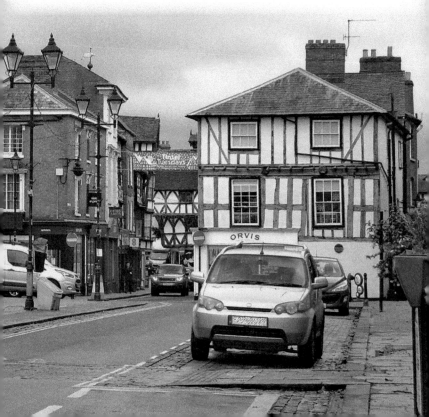

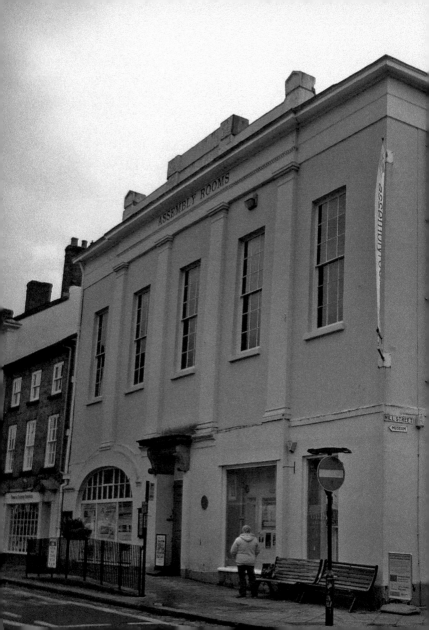

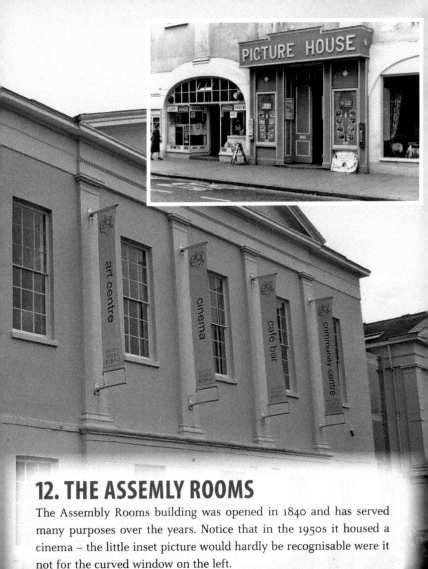

12. THE ASSEMBLY ROOMS

The Assembly Rooms building was opened in 1840 and has served many purposes over the years. Notice that in the 1950s it housed a cinema – the little inset picture would hardly be recognisable were it not for the curved window on the left.

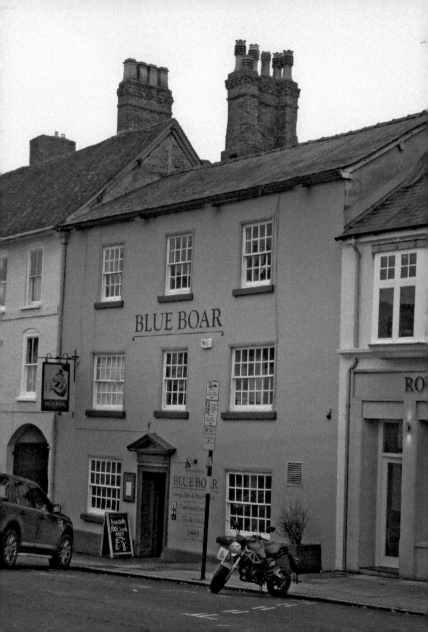

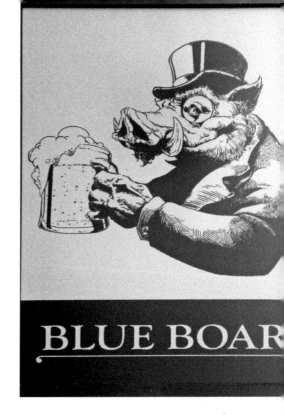

13. MILL STREET – THE BLUE BOAR

Is this the most haunted pub in Shropshire? There's a cavalier who is regularly seen strolling through the ground floor bar area; there's an elderly lady on the first floor who's thought to have been a school teacher who once lodged here; there's an elderly man sometimes seen sobbing on the second floor; there's someone who keeps turning the taps of beer casks off … and that's just some of the strange goings on in this pub.

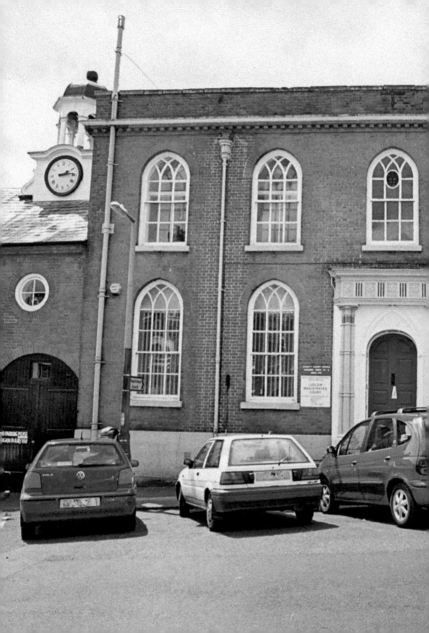

14. MILL STREET – THE GUILDHALL

Believe it or not this building dates from the early 1400s when it was said to be equalled only by the Bishop's Palace in Hereford. The Georgian façade was added in 1768. In medieval times the Palmers' Guild, whose hall this was, could be said to have run this town – they owned around a third of the town, including almshouses and the grammar school we'll visit next, as well as properties outside Ludlow.

15. MILL STREET – LUDLOW COLLEGE

Ludlow College can trace its history back to the early thirteenth century, making it one of the earliest surviving educational establishments in the country. It was founded by the Palmers' Guild as a school primarily for the sons of members of the guild. These days the school is a sixth form college for both boys and girls.

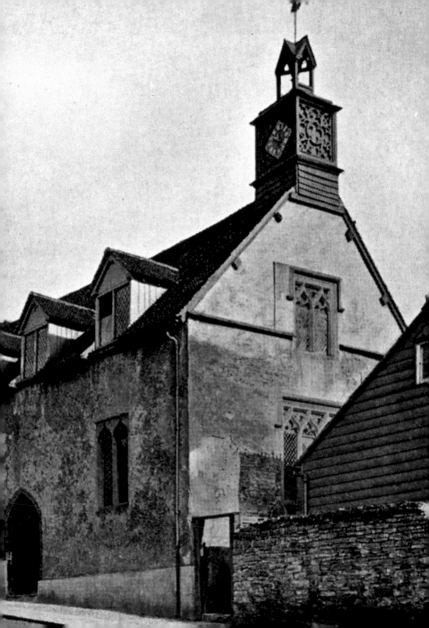

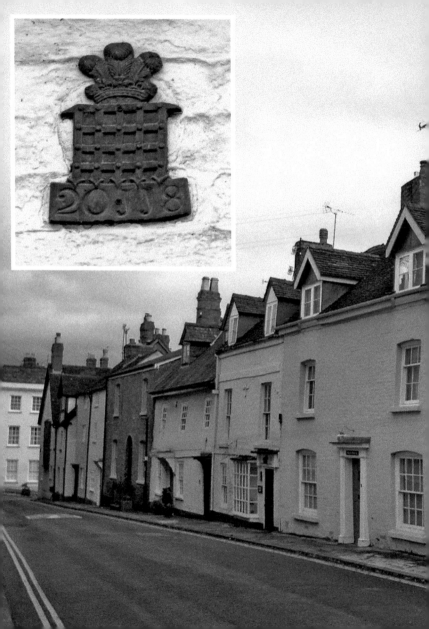

16. BELL LANE

Here the architecture is no longer so imposing. Bell Lane and Raven Lane (which crosses it) were originally minor streets to serve the rear entrances (to stables, servants accommodation and the like) for those grand mansions that face onto Mill Street and Broad Street. Notice one building has a fire mark badge on the wall – for some reason it's for the Westminster Fire Office, not exactly a local company.

LOWER RAVEN LANE

17. BROAD STREET

With its wonderful mix of architectural styles from medieval and Georgian to Victorian it's no wonder that Nikolaus Pevsner, the architectural historian, once described Broad Street as 'one of the most memorable streets' in England. Standing here we are looking down towards the inappropriately named Broad Gate, the only surviving of the seven gates that once gave access in and out of the town.

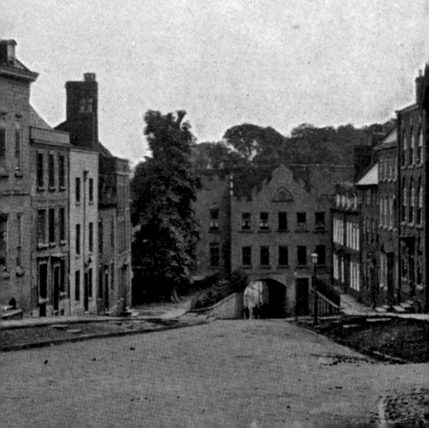

18. LOWER BROAD STREET

Walking down Broad Street you will have noticed the strange way the road has been dug down below the natural level of the street. Here in Lower Broad Street the road has been raised instead. This was a deliberate transformation by the engineer, Thomas Telford, providing horses pulling stagecoaches up and down the street an easier slope on which to travel. Telford is better known for his many roads, bridges, canals, ports, churches...

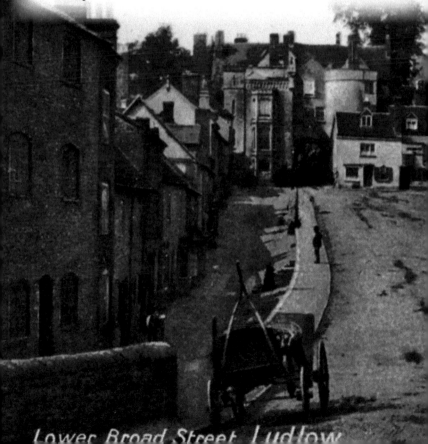

Lower Broad Street Ludlow

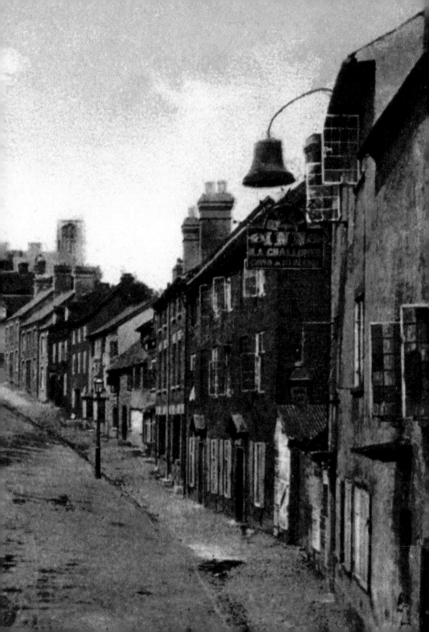

19. LUDFORD BRIDGE

The Ludford Bridge dates from the fifteenth century and it was here in 1459, during what are now known as the Wars of the Roses, that there was a skirmish that has come to be known as the Battle of Ludford Bridge. It was the Lancastrians who won that time and they then proceeded to sack the town and 'went wet-shod in wine, bore away bedding, clothing and other stuff and defouled many women'.

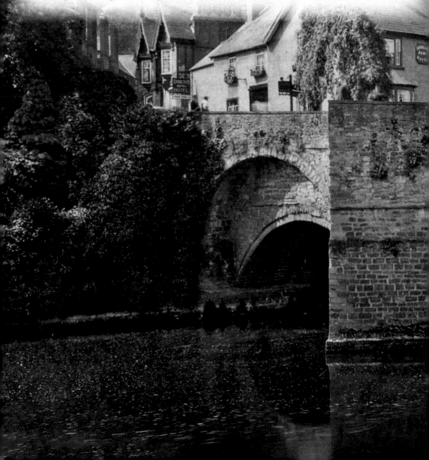

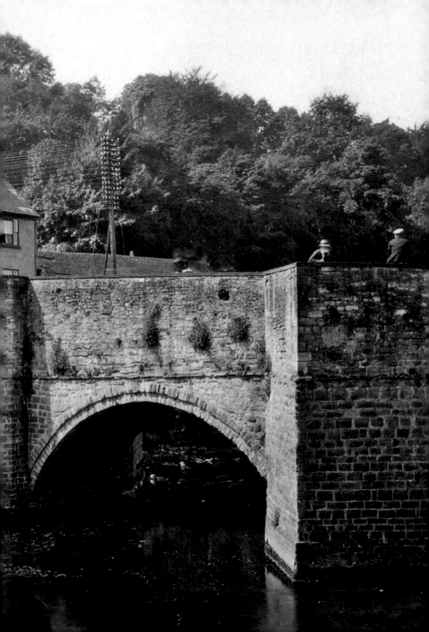

20. THE RIVER TEME

The delightfully named Horseshoe Weir sits roughly where, in times long past, there would have been a fording point across the River Teme. There are a number of weirs along this stretch of the river, which were constructed to ensure a constant supply of water to run the mills used to produce the woollen cloth for which the town was famous.

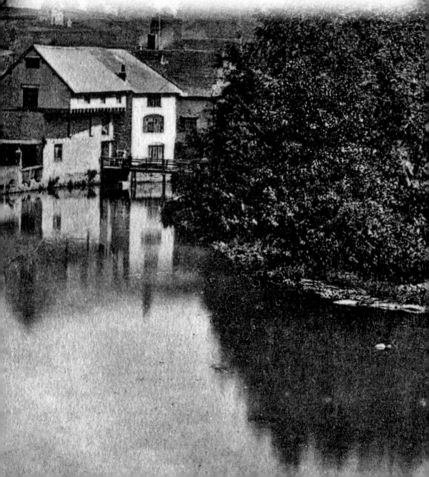

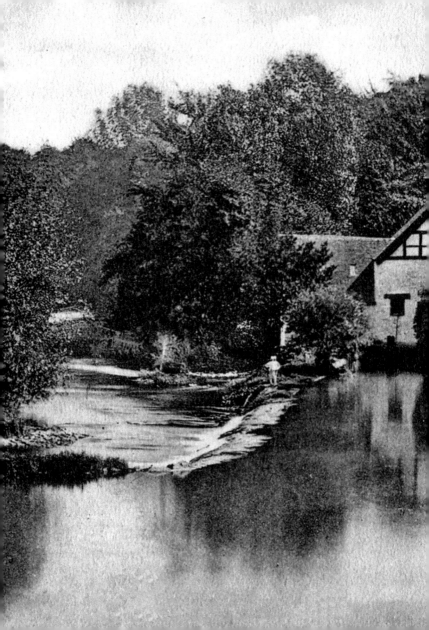

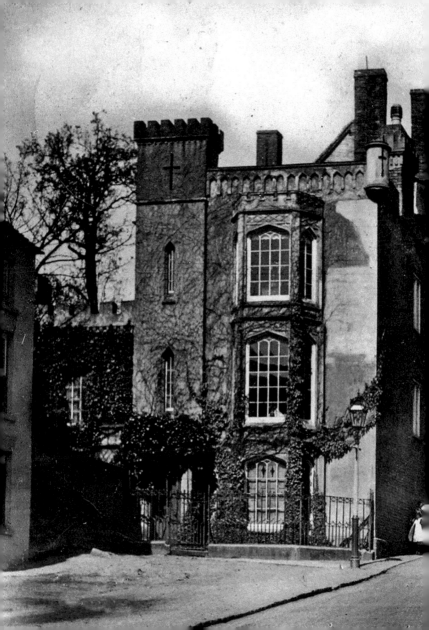

21. THE BROADGATE

Perhaps it would be more appropriate to call this the Narrow Gate. Ludlow's town walls were built in the mid-thirteenth century and extended for around a mile. Originally there would have been a deep moat just outside the wall, which, as you can see here, is straddled by the Wheatsheaf pub to the right – the pub dates from the 1600s so presumably its foundations have now settled and the building is secure!

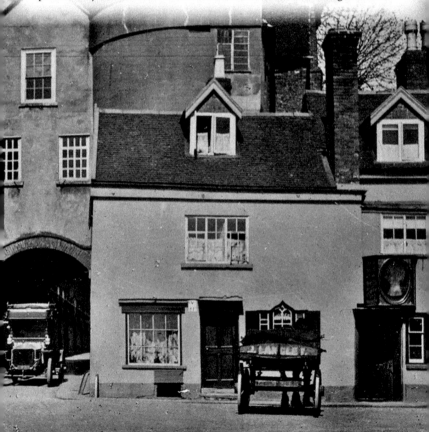

The Gate House, Ludlow.

22. BROAD STREET – THE BROADGATE

One thing that fascinates me about the rear of the Broadgate building is the variety of styles of all the windows. With their increasingly large window panes and narrowing glazing bars, they are a clear indication of how windows developed over time.

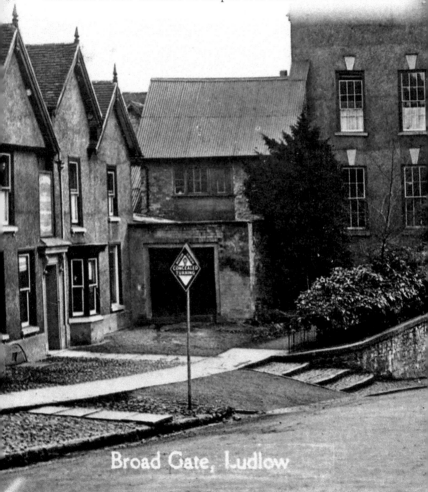

Broad Gate, Ludlow

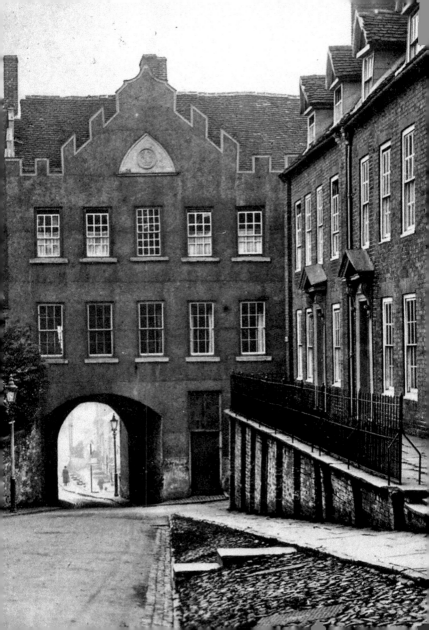

23. BROAD STREET – THE OLD BANK

Do take time as you walk up Broad Street to study the differing details of the buildings – can you find the house with fake fanlights over its windows (it's No. 39)? At No. 18 it's the doors that tell a story. Apparently this building was once a private bank but the banker's wife didn't want her husband's customers coming into the house through her hallway and so the second door was inserted.

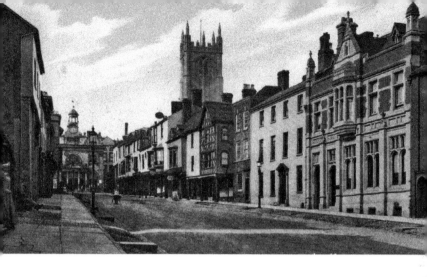

24. BROAD STREET – LLOYDS BANK

Notice the beehive carved over the entrance to the bank. Lloyds Bank was founded in Birmingham in the 1760s and at that time it was the beehive, denoting the rewards of industry, that was the bank's symbol. That familiar black horse wasn't adopted until the late 1800s. So when you see a Lloyds Bank with a beehive over the door you know it's been a Lloyds Bank for a considerable amount of time.

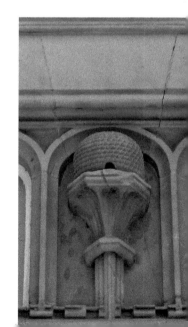

25. BROAD STREET – OLD ANGEL HOTEL

Now converted into apartments, this building was once the Angel Hotel. One famous visitor to the hotel was Admiral Horatio Nelson, who came to the town accompanied by his mistress, Emma, along with her husband, Lord Hamilton. In Nelson's time the hotel would have looked quite different, probably closer in appearance to the earlier photograph where there is plaster over all the timberwork.

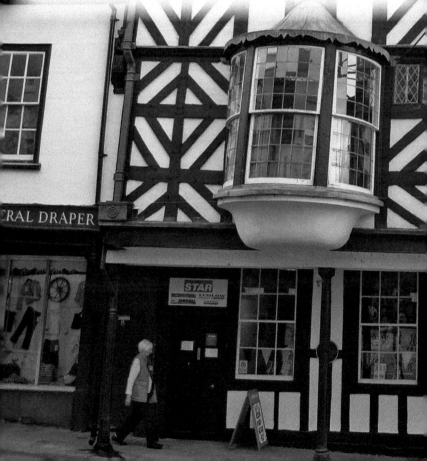

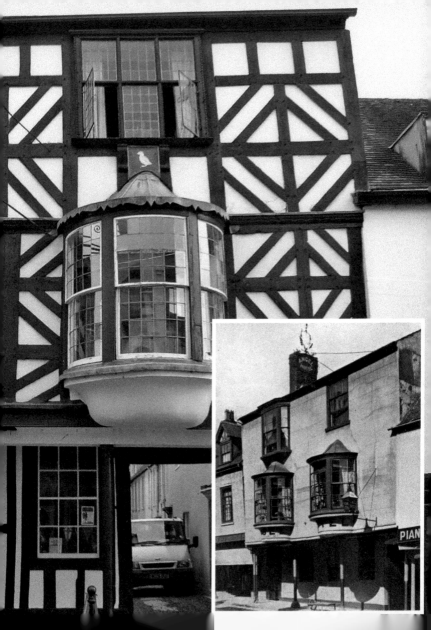

26. THE BUTTERCROSS

Standing proud at the top of Broad Street, the Buttercross is still occasionally used on market days. It was built in the 1740s, costing nearly £1,000, and in the late 1700s it housed a Blue Coat school (each pupil was given blue coat to wear, blue being the cheapest dye at the time). In the 1950s the town's museum was here. The museum then moved to the Assembly building but is now back here once again.

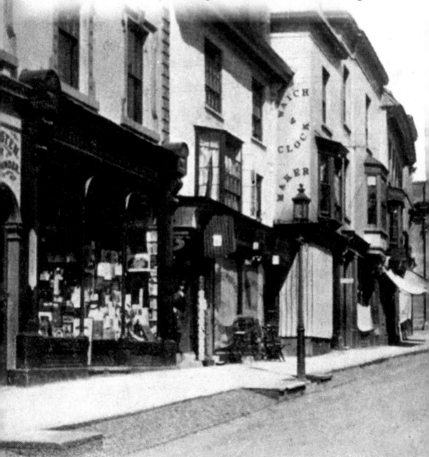

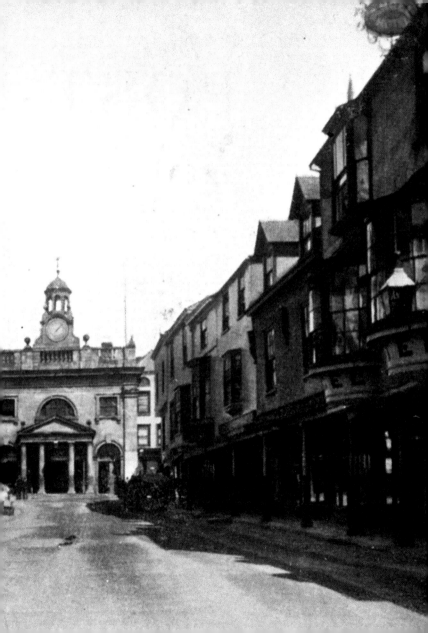

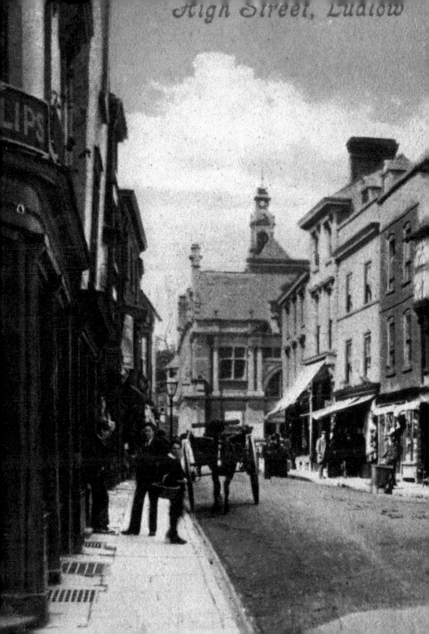

High Street, Ludlow

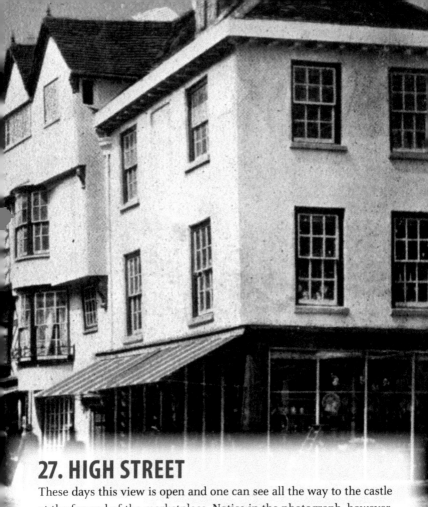

27. HIGH STREET

These days this view is open and one can see all the way to the castle at the far end of the marketplace. Notice in the photograph, however, the old town hall at the end of the street. Despite the fact that Nikolaus Pevsner hated the building and described it as 'Ludlow's bad luck' there was still a great deal of controversy in the town following the decision to knock it down.

28. BROAD STREET – BODENHAMS

This wonderful building at the top of Broad Street dates from the early 1400s. It was built by the Palmers' Guild right in the middle of what would then have been the open market. There were numerous different guilds in towns throughout medieval England and they were, in effect, the trade unions of their day. The Palmers' Guild was different as it was a national and semi-religious organisation and its members were usually individually wealthy.

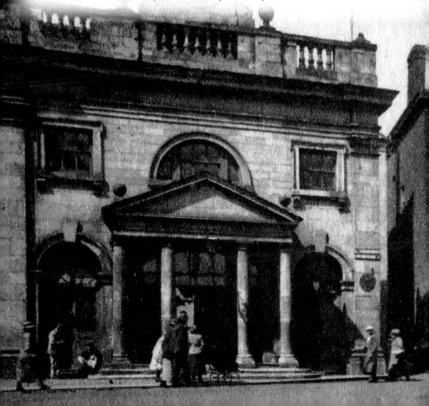

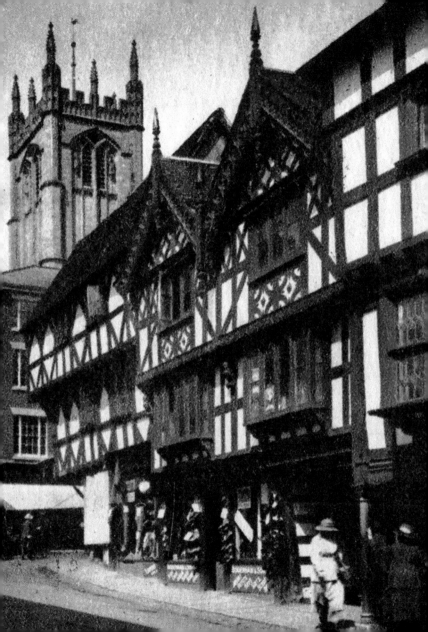

29. FISH STREET AND PEPPER LANE

This isn't exactly one of the most picturesque parts of Ludlow, but it's interesting when going along Pepper Lane to bear in mind that it marks the southern edge of the former medieval marketplace. So, as you walk here, try to imagine a time when all the buildings on your left between this lane and the church weren't there and instead it was open land where cattle or other livestock were sold.

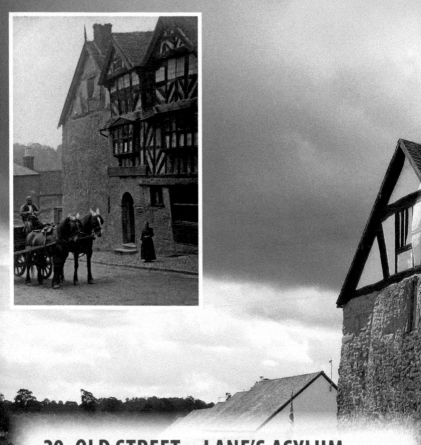

30. OLD STREET – LANE'S ASYLUM

I'm not sure I would want to live in a house described as an asylum. In the mid-1500s this was the home of Ludlow's MP, but it later came to be known as Lane's Asylum. The word has different connotations entirely now, but to give someone asylum really means to give them succour and help; however, in the days when this house was a workhouse those words, too, would have had somewhat different interpretations.

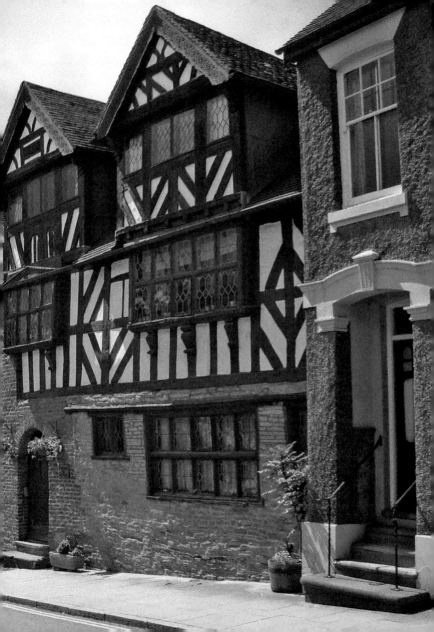

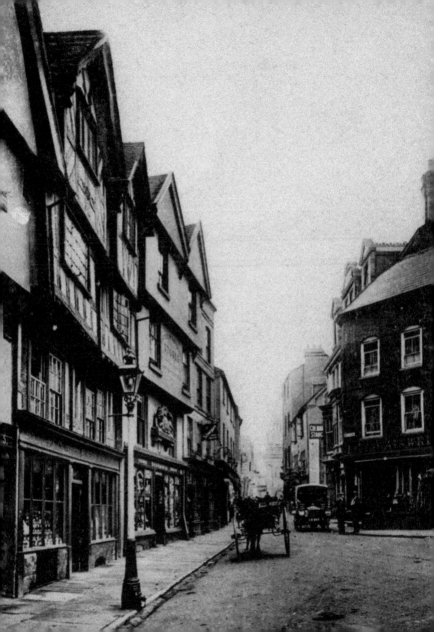

31. THE NARROWS

Officially the road ahead is known as King Street, but it should come as no surprise that it was once referred to as The Narrows. This was once all part of that open market but over the centuries buildings steadily encroached on the open land so that those buildings to the right of King Street serve to obliterate any view of the church behind – trade was obviously more important than religion!

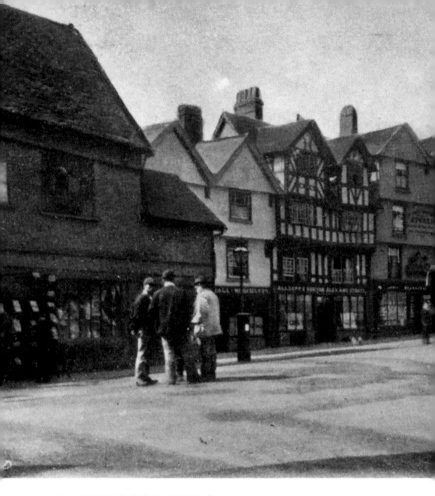

32. THE BULL RING

This must have been a hive of activity on market days in the past. People came to trade in Ludlow from far and wide. There are records, for example, of a button maker coming all the way from Worcester, a

felt maker from Brecon and a glass vendor from Bromyard. However, this part of the market was where livestock would have been sold so that it was also once known as the Beaste Market.

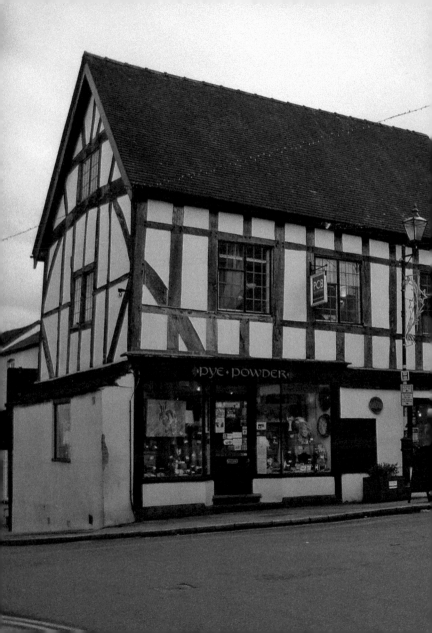

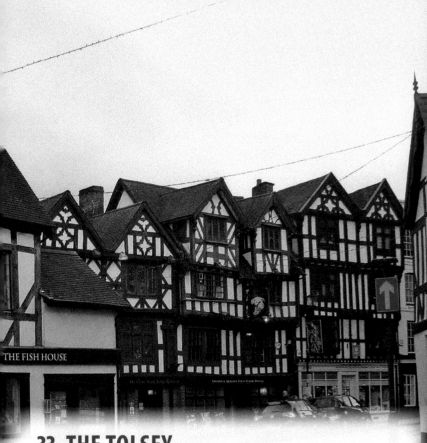

THE FISH HOUSE

33. THE TOLSEY

We've already seen how large the original open market was. This building, the Tolsey or toll house where people would pay in order to trade, marks the entrance to that market. The shop's name – Pye Powder – comes from the French *pied poudre* meaning 'dusty feet', and this was also a courthouse where people could argue their cases before they had even washed the dust from their feet.

34. CORVE STREET

Corve Street is the main street heading north towards Shrewsbury. Notice how just beside the Compass pub the road widens quite considerably. This would once have happened naturally just outside the north gate of Ludlow, but all traces of that gate have long since disappeared. This part of Ludlow, just beyond the town walls, suffered considerable damage during the Civil War so that there are only a few earlier buildings that survive.

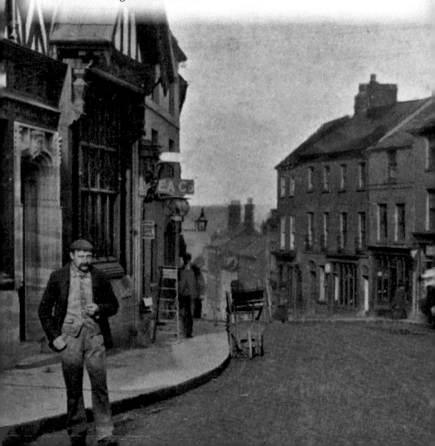

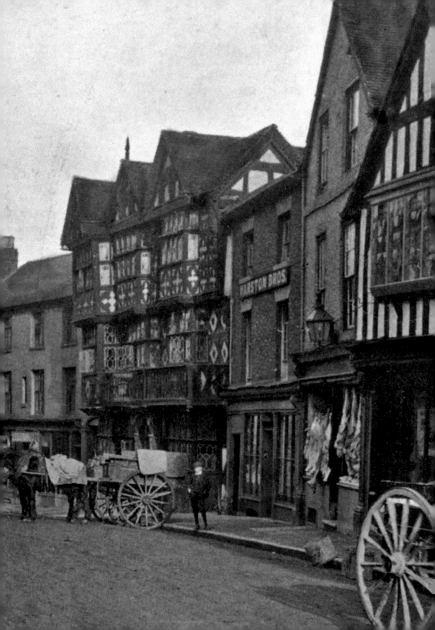

35. THE FEATHERS HOTEL

The famous Feathers Hotel dates back to the 1600s when it was the private home of a lawyer named Rhys Jones, whose initials can be clearly seen in the ironwork on the front door. By the end of the 1600s it had become an inn with stables behind capable of taking 100 horses. The balcony on the front of the building, however, is much later – it dates to the 1800s.

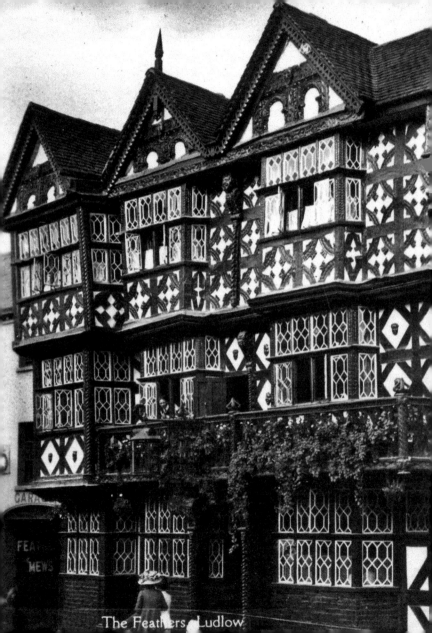

The Feathers, Ludlow

36. THE BULL HOTEL

The Bull Inn predates the Feathers across the road by a couple of centuries. It once served as a kind of medieval motel – there was stabling on the ground floor for the vehicles (horses in those days, of course) and accommodation above for the travellers. From the courtyard of the Bull walk up the steps at the end and into the churchyard beyond.

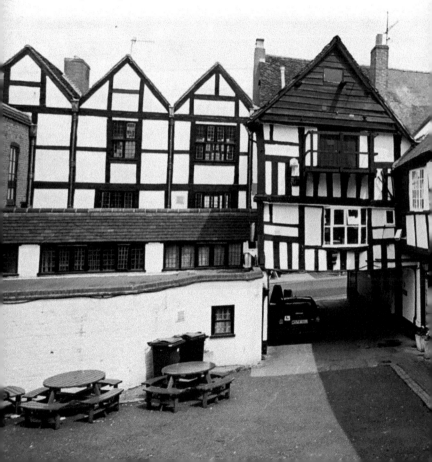

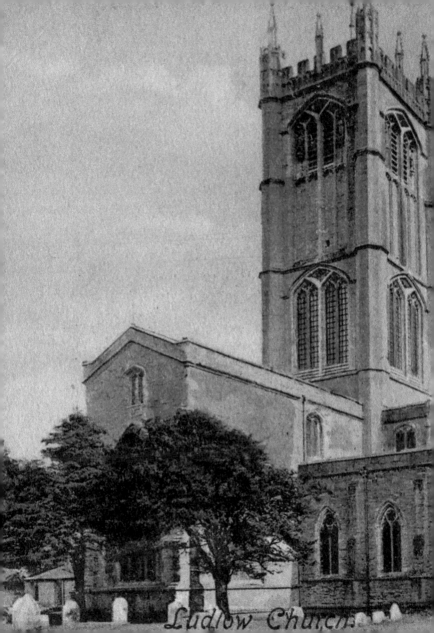

Ludlow Church.

37. ST LAWRENCE'S CHURCH – THE CHURCHYARD

It's quite a surprise, having walked around Ludlow's streets, to find this open area beside St Lawrence's Church and, once again, the view to the north reminds you of just why Ludlow's early castle sits on this hill. The first church on this site dates from the turn of the eleventh/twelfth centuries and it's understood that when the nave was built an ancient Bronze Age barrow was demolished first.

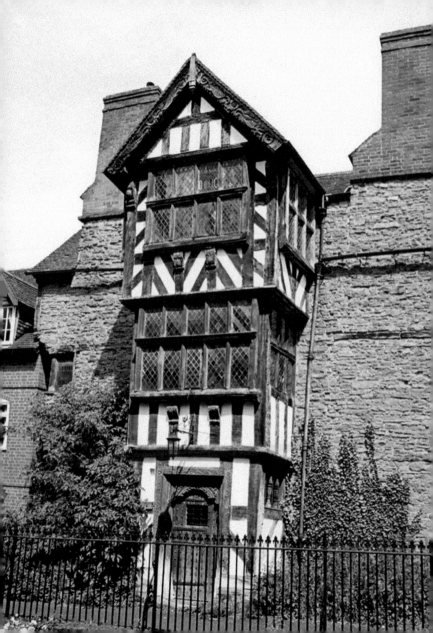

38. THE READER'S HOUSE

This delightfully carved porch is a seventeenth-century addition to an earlier medieval stone building. Originally one of the many properties belonging to the Palmers' Guild, it was used to house the schoolmaster of the early grammar school. By the time the porch was added it had become home to the chaplain to the Council of the Marches. Its present name, however, the Reader's House, dates from the 1700s when it became the home of the reader, or lecturer, appointed to serve the church.

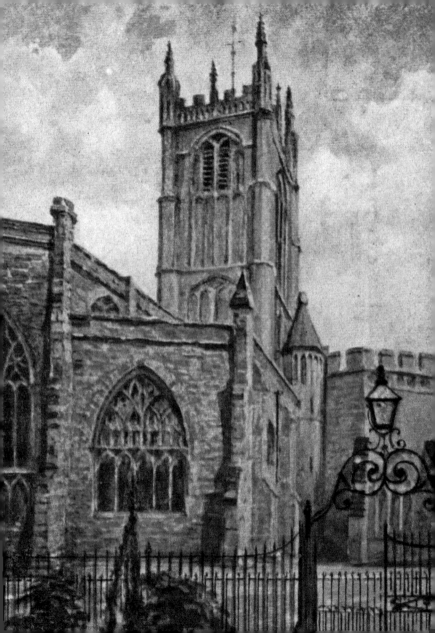

39. A. E. HOUSMAN

Before you leave the churchyard look out for the plaque on the wall dedicated to the poet A. E. Housman. Despite his book, *A Shropshire Lad*, published in 1896, Housman was not a Shropshire lad himself – he was born in Bromsgrove. As a boy he knew this area well, however, and this is reflected in the emotive poetry he later wrote. As you leave the churchyard look towards the west door – the cherry tree there serves as another memorial to Housman.

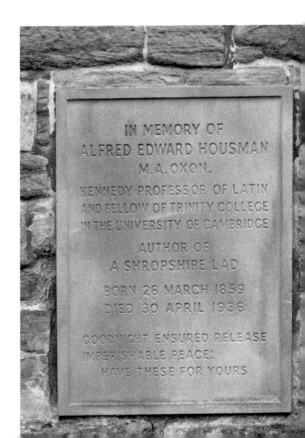

IN MEMORY OF
ALFRED EDWARD HOUSMAN
M.A. OXON.
KENNEDY PROFESSOR OF LATIN
AND FELLOW OF TRINITY COLLEGE
IN THE UNIVERSITY OF CAMBRIDGE

AUTHOR OF
A SHROPSHIRE LAD

BORN 26 MARCH 1859
DIED 30 APRIL 1936

GOODNIGHT. ENSURED RELEASE
IMPERISHABLE PEACE:
HAVE THESE FOR YOURS

40. COLLEGE STREET

Once one of the seven gates that surrounded the town of Ludlow, the Linnhe gate has almost completely disappeared. This was only a postern gate rather than a main gate of the town and led down to the fields below and the area known as Linney, hence the gate's name. Incidentally, during the Second World War Ludlow was fortunate in that only one bomb fell on the town – here in College Street. Fortunately no one was killed.

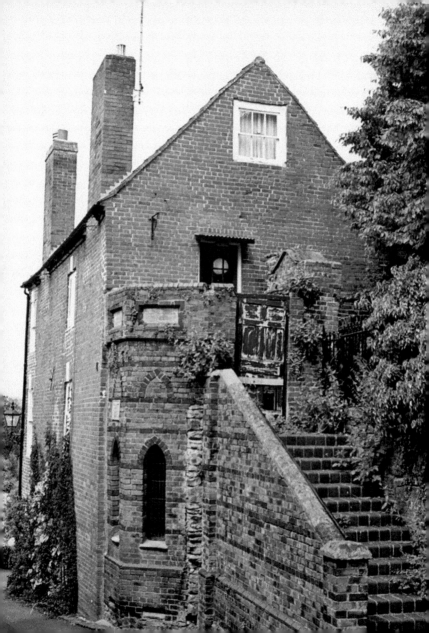

41. HOSIER'S ALMSHOUSES

The original almshouses on this site were built in the late 1400s by local cloth merchant John Hosier. Still known as Hosier's Almshouses, the present almshouses were built by the Shropshire architect T. F. Pritchard in the 1750s. Notice the crest over the entrance, which displays the lion of the Mortimer family, the white roses of the House of York and the feathers of the Prince of Wales – all once associated with the town.

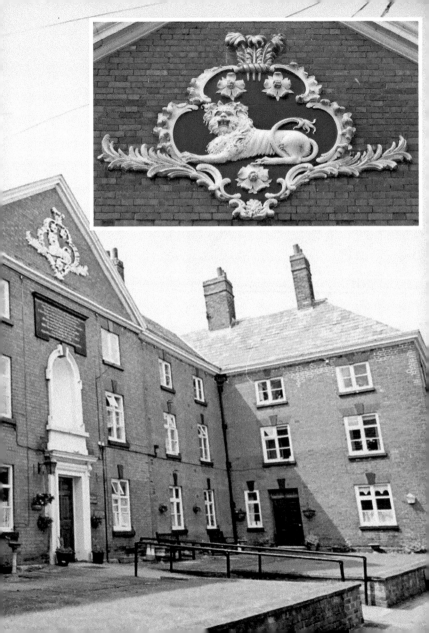

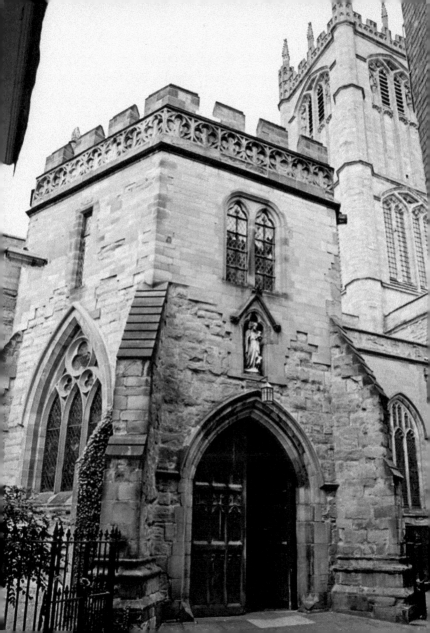

42. ST LAWRENCE'S CHURCH – THE PORCH

In his book *England's Thousand Best Churches*, St Lawrence's was one of only eighteen churches to be given a five-star rating by Simon Jenkins. For a church that's so grand (it has been described as the cathedral of the Marches, the borderland with Wales) the way its entrance is almost hidden from view comes as a total surprise. The porch itself is most unusual in that it's hexagonal in shape, one of only three examples in England.

43. ST LAWRENCE'S CHURCH – THE INTERIOR

At 203 feet long, St Lawrence's is one of the largest parish churches in the country. As soon as you enter the building you can see how the wealth of Ludlow was expressed in the building of this fine church. Take time to wander all around the church – the misericords (carved seats) in the chancel are an absolute delight. Also somewhere in the chancel lies the heart of Prince Arthur, eldest son of Henry VII.

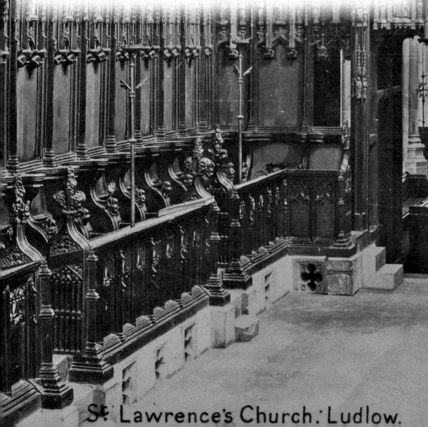

St Lawrence's Church: Ludlow.

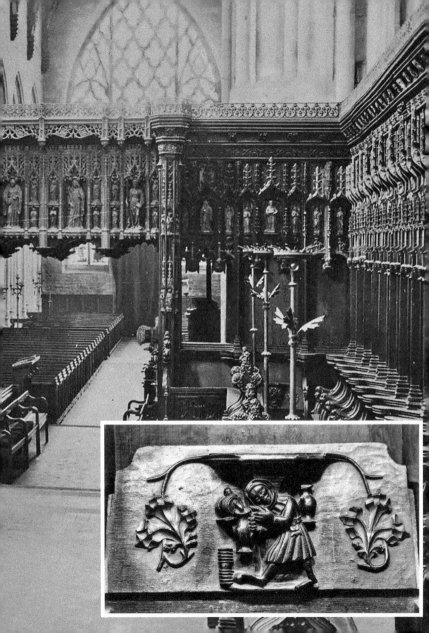

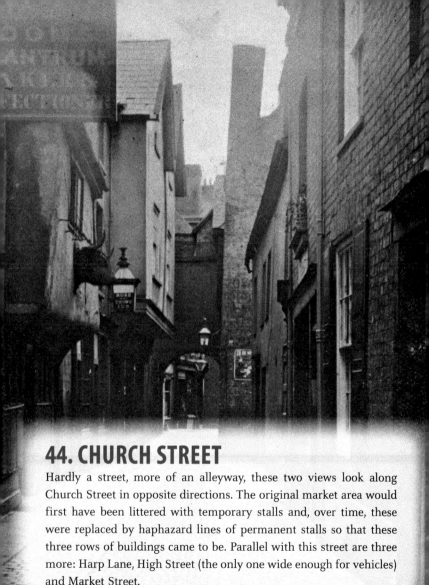

44. CHURCH STREET

Hardly a street, more of an alleyway, these two views look along Church Street in opposite directions. The original market area would first have been littered with temporary stalls and, over time, these were replaced by haphazard lines of permanent stalls so that these three rows of buildings came to be. Parallel with this street are three more: Harp Lane, High Street (the only one wide enough for vehicles) and Market Street.

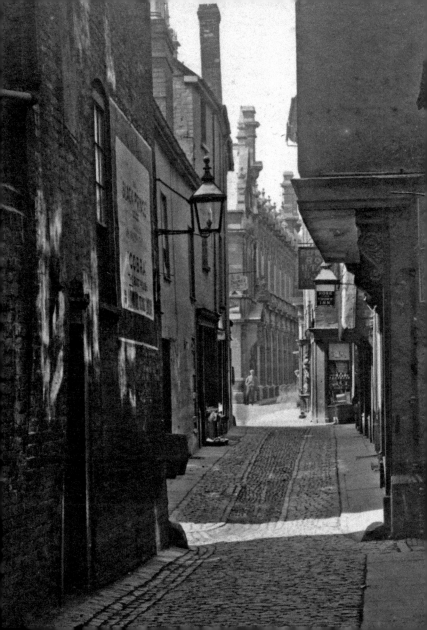

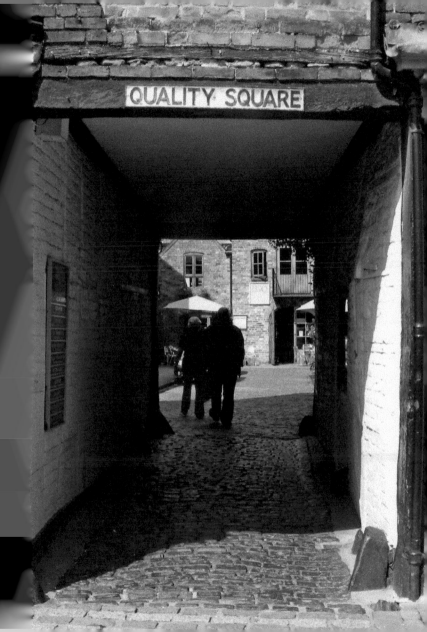

45. QUALITY SQUARE

I love the name Quality Square. This open square was once the courtyard of a grand mansion, big enough even to have a long gallery within it – not something commonly found in town houses where space would have been at a premium even for the wealthy. As an administrative, legal and social centre Ludlow had a number of substantial properties described in the late 1500s as 'fayre houses'.

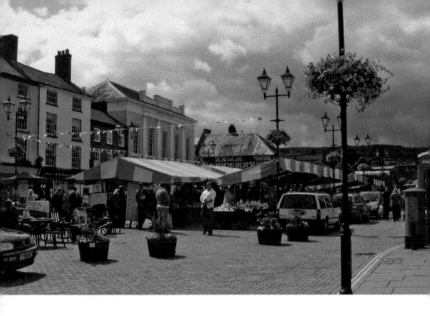

46. THE MARKET SQUARE

We have now returned to the opposite end of the open market from where we started this tour, and standing here it is easy to see how the castle would have dominated not just the marketplace but the whole town and all of its inhabitants. With luck you'll find a market in progress and will now have time to browse. I usually head straight for the book stalls and antiques!